ART SCHOOL

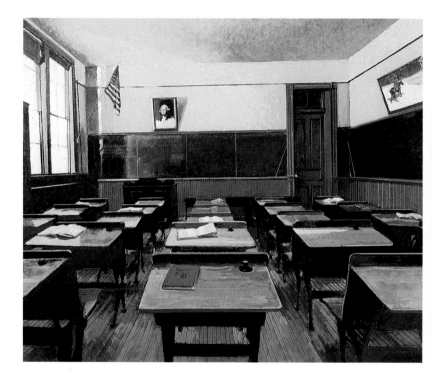

SCHOOLROOM

ART SCHOOL

Paintings by
GEORGE DEEM

Introduction by Irene McManus

THAMES AND HUDSON

Produced in conjunction with
Evansville Museum of Arts and Science
touring exhibition, 'School of ...'

Printed and bound in Singapore
by C.S. Graphics

Contents

Introduction

The paintings in this book are wonderfully funny, as well as being a labor of intense love and joy in art—yet the man who has spent years making them may have heartfelt reasons for his compulsion to reinvent the great works of other painters. His recomposed masterpieces probably say as much about himself as about the artists he quotes.

George Deem was born in Vincennes, Indiana, on August 18, 1932—the first-born of a pair of identical twin brothers. His mother died of tuberculosis on January 19, 1937, when George was four years old. His twin brother, John, died of measles and rheumatic fever a little over a year later, on April 23, 1938. "I withdrew," recalls Deem. "I went under. I wasn't unhappy, though. I don't call this a sad childhood. I call it a wonderful childhood." He fondly remembers the schoolroom where as a dreamy child he was chivvied along by a Benedictine nun, Sister Bertilla, who took a kind enough interest in him to give him drawing lessons after he left her care.

School of Thought may evoke Magritte, but it is pure autobiography, insists Deem: "That is *me*, in my school-room. I can even tell you where I sat, it's so close to historic

reality. I was painting a plain Indiana schoolroom, and suddenly the sky came in, and I made up these clouds, this school of thought or dreams. It was in this schoolroom that poetry, magic, sex—*everything*—developed in this quiet and inexpressible way."

But Deem is equally clear that all of his art-quoting paintings are "autobiographical," and he is obviously fascinated by serial structures, most especially by a kind of ingenious "twinning" in his juxtapositions of the life model and master's or student's images of the model, beside passages of "art-within-art" such as mirrors, paintings, doorways, and windows.

Deem's favorite painter, Vermeer, was the inspiration for the *School of…* series. In the sixties and seventies Deem had been quoting and rearranging masterpieces, reproducing not only superficial image, but also style and technique, painstakingly observed at museums and in good art books—art books with a lot of technical information. Enthralled by the Dutch master, Deem spent seven years creating a body of sparkling new Vermeers, sometimes wittily juxtaposing the painter with other artists, as in *Italian Vermeer (Caravaggio)*, where Vermeer's placid domestic interior seems to have been struck by some kind of Latin vendetta. In 1984, Deem sceptically noted an attribution of *The Girl with a Red Hat* to "School of Vermeer," and decided to reinvent his Indiana schoolroom as a Vermeer art class: a fallen drawing on the floor is a student sketch of the *Maidservant Pouring Milk*, the life model posed at the head of the class (Deem's earliest repeat pairing in the *School of…* series), while *The Girl*

with a Red Hat sits prominently on a student desk—perhaps Deem's *own* desk.

Deem's fraternal identification with Vermeer goes deep: "I used to dream about him—I talked to him. He died in 1675. I was in Italy painting him in 1975, the anniversary of his death, and I became very nervous and inhibited. I was afraid I would *lose* him. He slowly left—but then I found I could do more with him, manipulate his images more freely." Vermeer was born in 1632—precisely three hundred years before Deem and his lost twin brother. Still entranced by Vermeer, Deem visited and viewed Delft on the anniversary of his own birthday a few years ago.

Vermeer appears to have magically healed the void created by Deem's lost "mirror-identity," his twin brother John. Deem may seek this mirror-identity in all the artists who attract his eye—though admittedly he has sometimes astonished even himself with his mediumistic abilities: "It was a frightening revelation to me that I could do Matisse. I got depressed because I don't like to use that much color. But he taught me to relax—to just do it, don't work up to it." In Deem's Matisse venture, one artwork appears in two canvases: *School of Matisse 2* liberates the figures from *Dance*, present in a simple student sketch in *School of Matisse 1*. *School of Matisse 2*, where Deem out-decorates the master, must be one of the most outrageous and hilarious paintings in this book.

All these artists have taught Deem something—the series has really been an art school. Ingres, for instance, taught Deem to: "draw it first—he knows the first stroke is *it*." In Deem's sumptuously Napoleonic *School of Ingres*, hung all

9

round with the works of the master (skillfully rendered in perspective), Deem proposes that the model for today's life class is (who else?) the lush bather of Valpinçon, perched on a desk and chatting amiably with Oedipus, the life model from next door, during class recess. Standing at the blackboard, instructing the class on how to draw the bather, is the dashing young Ingres of a self-portrait. The exquisite Comtesse D'Haussonville stands pertly by, plainly unimpressed by the life class turned lolling harem at the end of the schoolroom, where we glimpse some of the twenty-three bodies the aging Ingres sardined into his *Turkish Bath*—including the distant, diminutive twin of the Valpinçon bather, recycled by Ingres as a mandolin player at the bath.

For *School of Hopper* Deem mischievously envisaged: "depression lessons like robbery and prostitution, in an art school for adults who can only meet on Sunday mornings." Hence the painting *Early Sunday Morning* displayed at the head of the class, a canvas which mirrors the view through the window behind the *Nighthawks* diners, who are Deem's class instructors. The slatternly nude from *Eleven A.M.* amusingly fixes the exact time of day for us.

The schoolmistress in Deem's fiendishly conceived *School of Balthus* is the Vicomtesse de Noailles, an elegant patron of the arts who also happened to be a descendant of the Marquis de Sade—a significant family connection considering the playful eroticism of Deem's parody of Balthus. In the original, the young model of *Thérèse Dreaming* bends both legs at the knee. In Deem, Thérèse's right knee stretches across the desk in an attitude mimicking

the luxurious self-abandonment of the voluptuous young nude of *The Room*, exposed to the light by her sinister dwarf attendant. Deem sets up a series of sardonic twinnings: between the smocked schoolboy and card-playing girl facing each other with one foot on the ground, one knee on a chair; between the two girls on all fours, rumps in the air; and between the two girls who are nude—one in an amorous swoon, balanced by the other apparently more wholesome, less exposed nude in stately Egyptian profile. A hidden pair of twins (one wholesome, one absolutely not) lurk in Deem's inclusion in his painting of the workman in white from *The Street*, since one reading of the Balthus painting interprets the workman as Lewis Carroll's carpenter from *Through the Looking-Glass*, crossing the street between Tweedledum and Tweedledee—Tweedledee too lost in a daydream to notice that his dark twin Tweedledum is molesting Alice.

In quoting Chardin's great painting *The Governess*, Deem removes the eponymous leading player: the shamefaced schoolboy lowers his gaze, but no recriminating governess confronts him. In art quotation or "juxtaposition" (Deem frequently calls himself a "juxtapositionist"), the choice to omit certain key figures from famous paintings becomes a dramatic device, compelling the spectator to ponder the artist's choices. But again, the *School of Chardin* has its element of twinning: in the lower left, the young draftsman appears in the painting of that name; in the upper right, this same young draftsman, magically sprung from his art-historical context, still raptly sharpens his black crayon in its twin crayon-

holder. Adding to the fun, the *Soap-Bubbles* boy blows an affectionate raspberry at Chardin's moral message of the transience and uncertainty of life, leaning cheekily *into* the schoolroom to pop his giant bubble (making inversion yet another lively choice in the theater of the juxtapositionist).

The deceptively twinned upper and lower halves of Deem's dazzling *School of Winslow Homer* juxtapose differing versions of Homer's nostalgically remembered schoolroom. Deem's illusionistic "actual" schoolroom quotes *Country School* (1871) while his desk sketch loosely quotes *New England Country School*—which Homer painted a year or two later, leaving out a few of the children. Deem goes a step further, making the school-mistress disappear, as he made Chardin's governess disappear. This painting is one of Deem's most effective and exciting explorations of the schoolroom theme. His mirroring of the room in a monochromatic sketch is brilliant—turning the drawing on the desk into a still, dark pool of reflective memory. The room itself has assumed a mirror-identity. The vanished children and schoolmistress in the twinned room sharpen our awareness of Homer's formal play of symmetry and asymmetry in the original paintings—as well as perhaps poignantly touching upon Deem's personal losses in his kindergarten year. Most vitally of all, Deem has transposed himself into this country schoolroom of Homer's—since he is the unseen student whose hand has, *in all truth*, produced the sketch on the solitary desk.

Irene McManus

The Plates

SCHOOL OF ATHENS

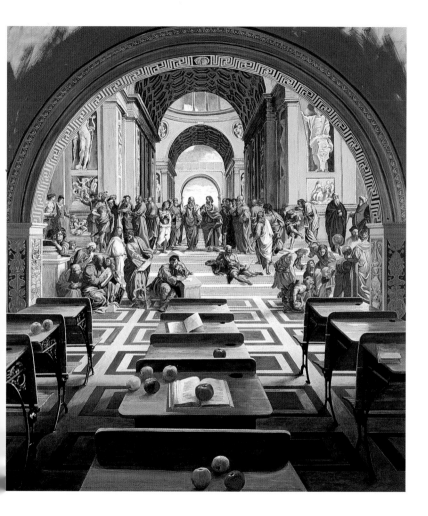

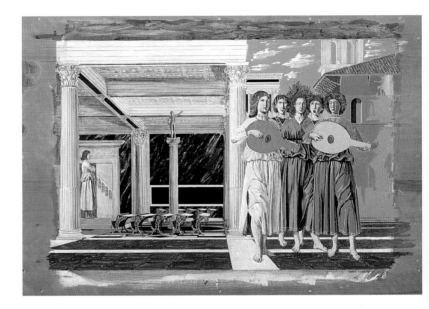

SCHOOL OF PIERO DELLA FRANCESCA

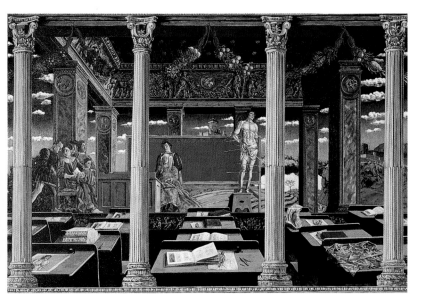

SCHOOL OF MANTEGNA

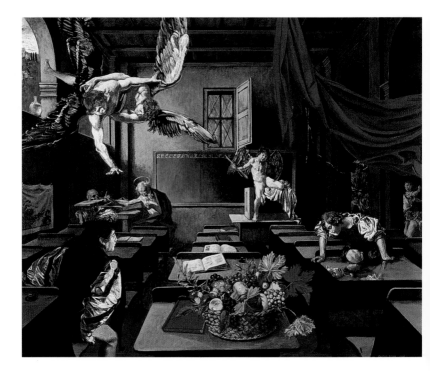

SCHOOL OF CARAVAGGIO
SCHOOL OF VERONESE

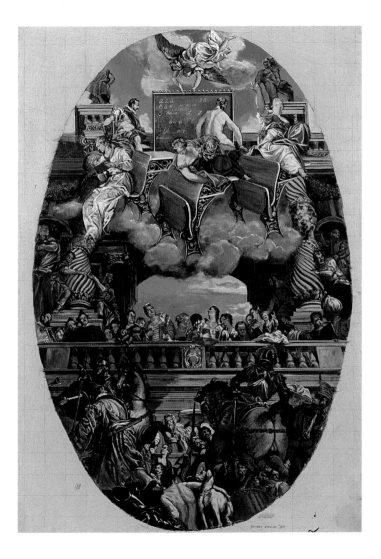

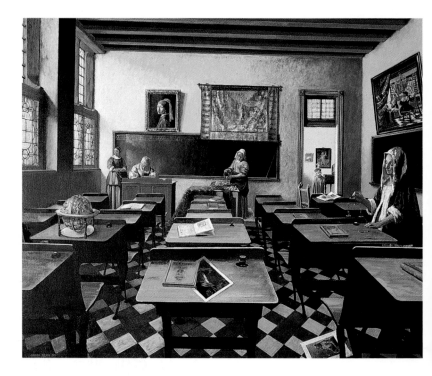

SCHOOL OF VERMEER
SCHOOL OF VELAZQUEZ

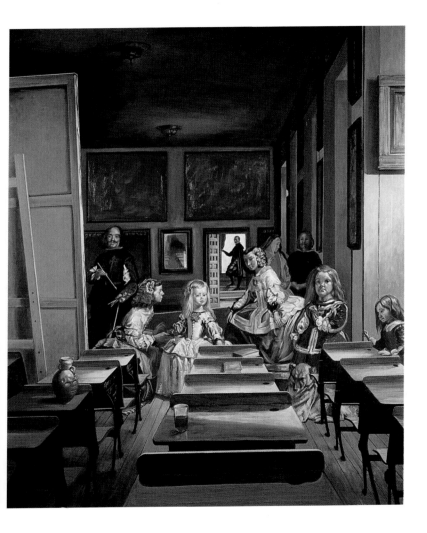

SCHOOL OF GEORGES DE LA TOUR

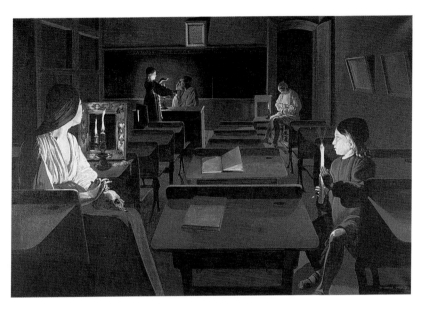

SCHOOL OF REMBRANDT

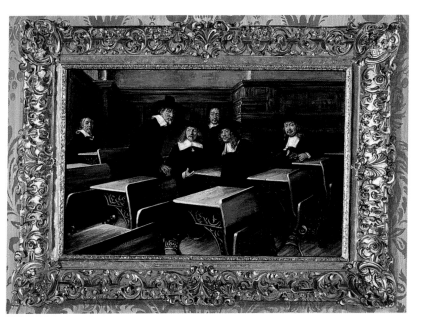

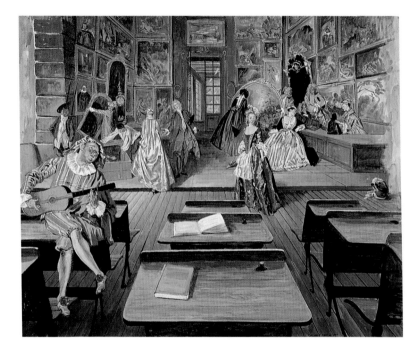

SCHOOL OF WATTEAU

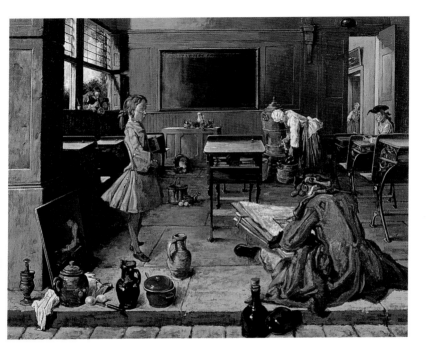

SCHOOL OF CHARDIN

SCHOOL OF CANALETTO 1

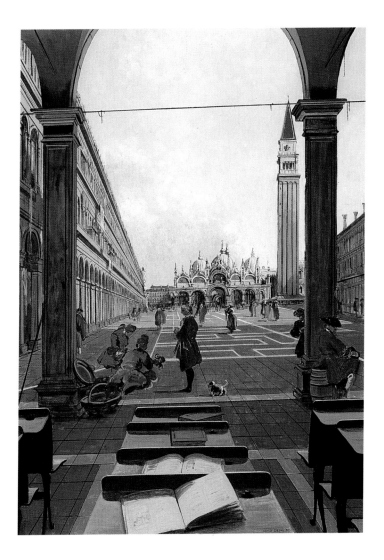

SCHOOL OF CANALETTO 2

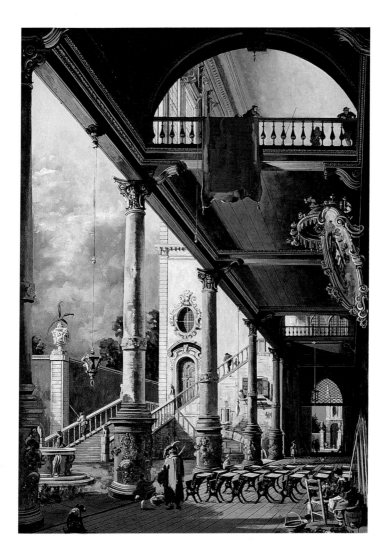

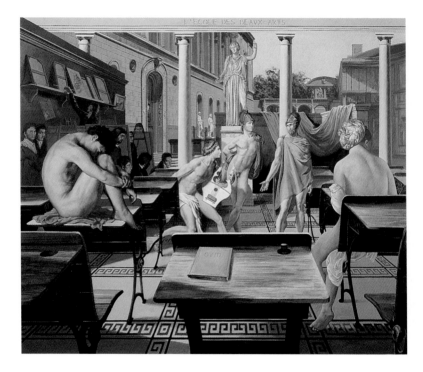

L'ECOLE DES BEAUX-ARTS

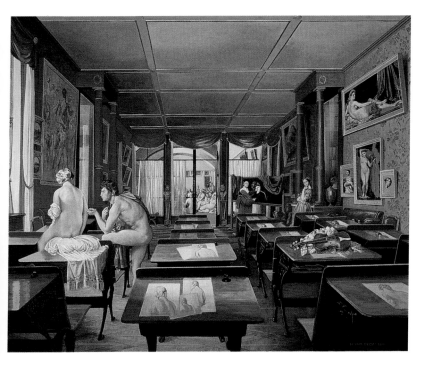

SCHOOL OF INGRES

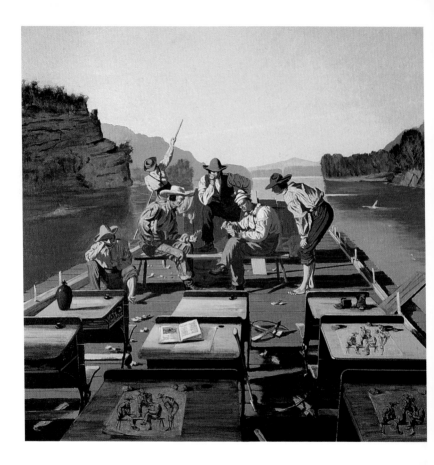

SCHOOL OF BINGHAM
HUDSON RIVER SCHOOL

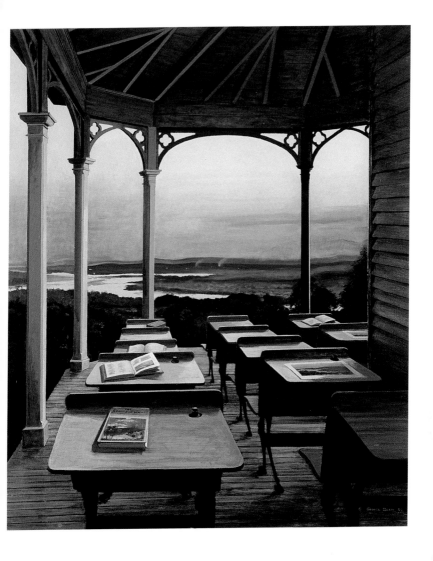

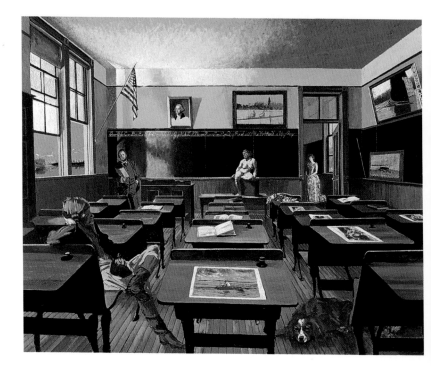

SCHOOL OF EAKINS
SCHOOL OF WINSLOW HOMER

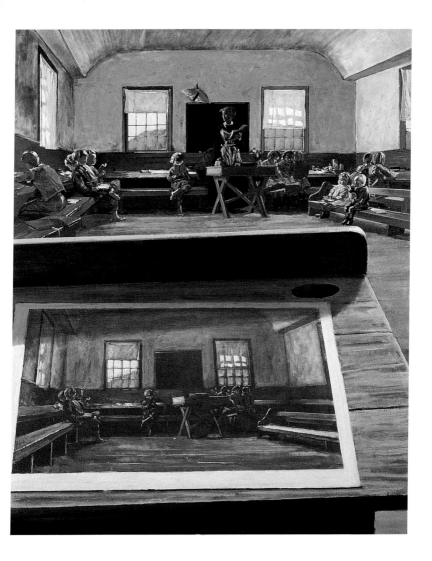

BARBIZON SCHOOL

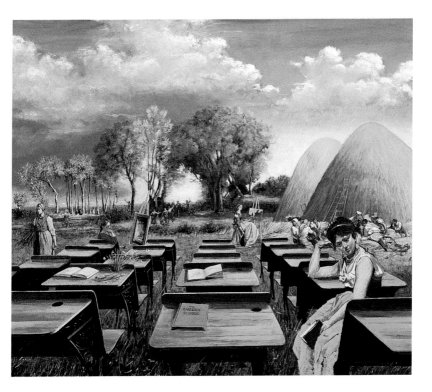

HOOSIER SCHOOL

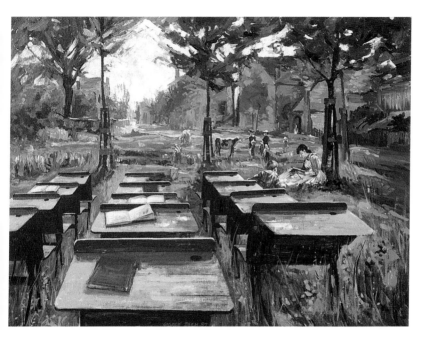

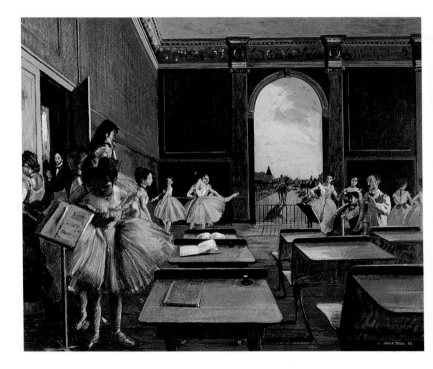

SCHOOL OF DEGAS
SCHOOL OF SARGENT

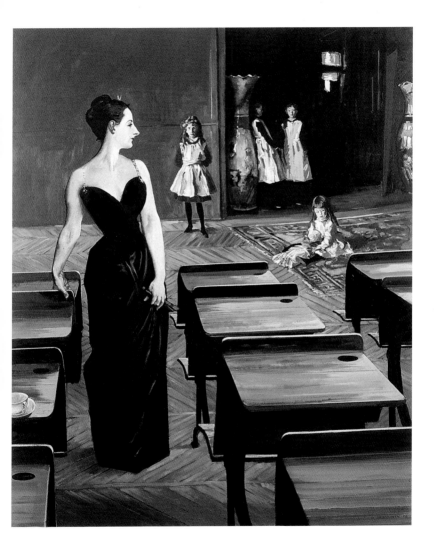

ASHCAN SCHOOL

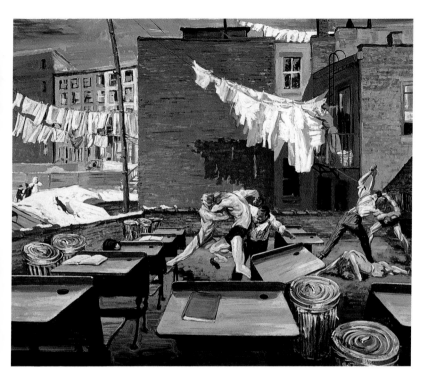

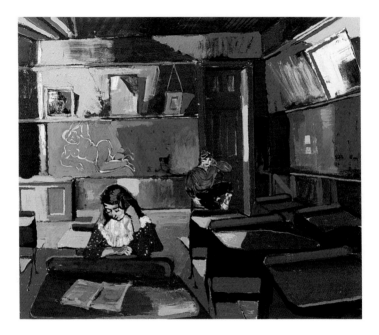

THE FAUVE SCHOOL

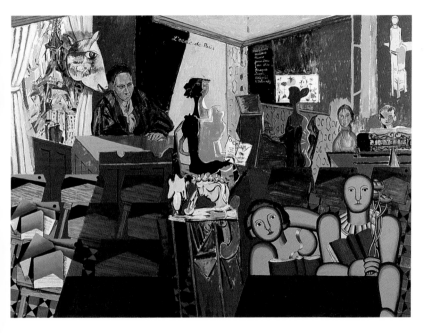

L'ECOLE DE PARIS

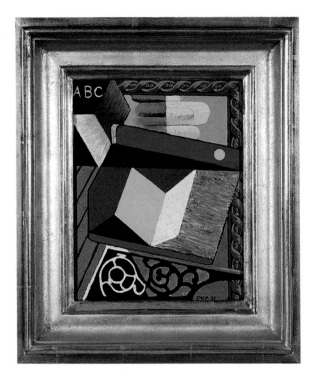

SCHOOL OF JUAN GRIS

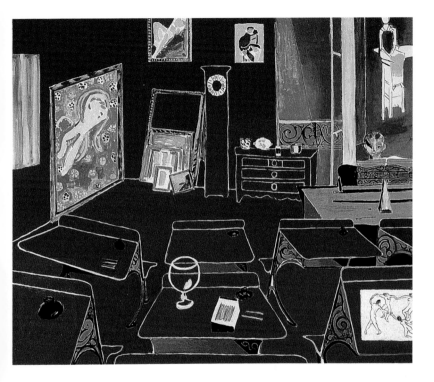

SCHOOL OF MATISSE 1

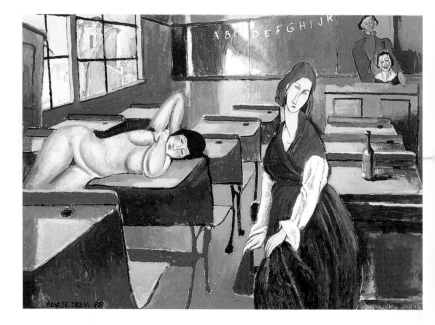

SCHOOL OF MODIGLIANI
SCHOOL OF MATISSE 2

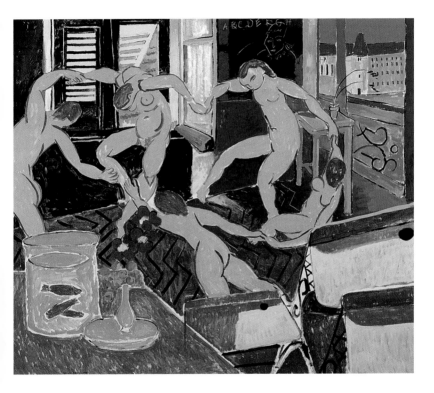

SCHOOL OF DE CHIRICO

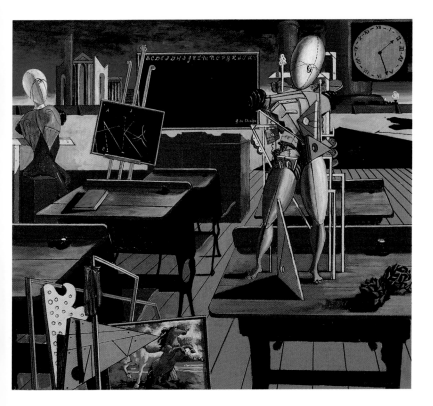

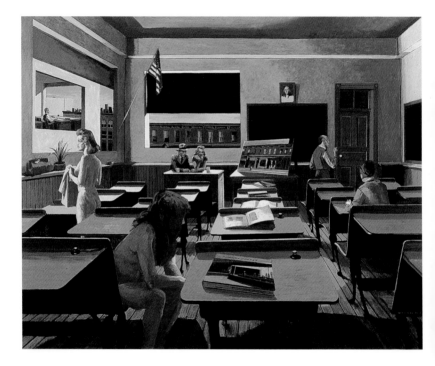

SCHOOL OF HOPPER

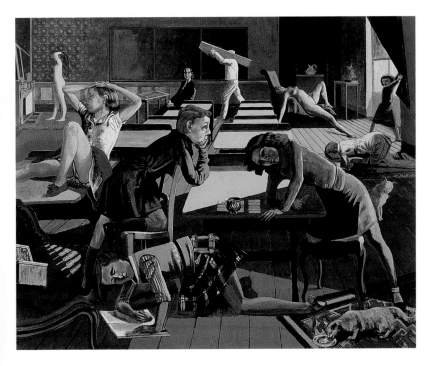

SCHOOL OF BALTHUS

SCHOOL OF STUART DAVIS

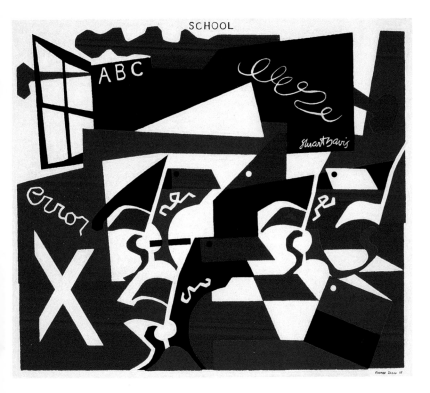

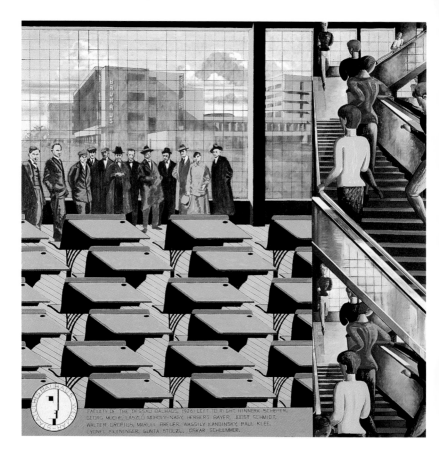

FACULTY OF THE DESSAU BAUHAUS, 1926: LEFT TO RIGHT: HINNERK SCHEPER,
GEORG MUCHE, LÁSZLÓ MOHOLY-NAGY, HERBERT BAYER, JOOST SCHMIDT,
WALTER GROPIUS, MARCEL BREUER, WASSILY KANDINSKY, PAUL KLEE,
LYONEL FEININGER, GUNTA STÖLZL, OSKAR SCHLEMMER.

BAUHAUS SCHOOL

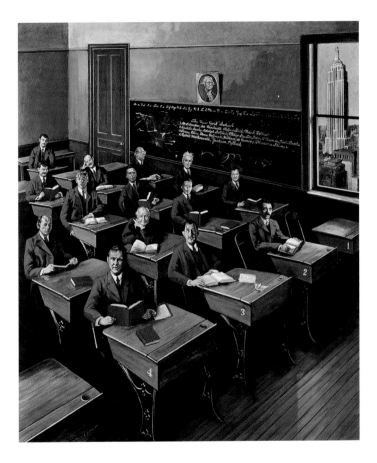

THE NEW YORK SCHOOL

List of Illustrations

61

SCHOOL OF CHARDIN
40 x 50 (102 x 127), oil on canvas, 1985
University Art Museum, Arizona State
University, Tempe, Arizona

SCHOOL OF CANALETTO 1
42 x 30 (107 x 76), oil on canvas, 1987
Mr. and Mrs. Mark Holeman,
Indianapolis, Indiana

SCHOOL OF CANALETTO 2
50 x 36 (127 x 91), oil on canvas, 1987
Nancy Hoffman Gallery, New York

L'ECOLE DES BEAUX-ARTS
58 x 70 (147 x 178), oil on canvas, 1991
Nancy Hoffman Gallery, New York

SCHOOL OF INGRES
40 x 50 (102 x 127), oil on canvas, 1985
Becton-Dickinson & Company, New
Jersey

SCHOOL OF BINGHAM
34 x 34 (86 x 86), oil on canvas, 1985
Collection of Hallmark Fine Art
Collection, Hallmark Cards, Inc.,
Kansas City, Missouri

HUDSON RIVER SCHOOL
48 x 40 (122 x 102), oil on canvas, 1985
Dow Jones & Company, New York

SCHOOL OF EAKINS
34 x 42 (86 x 107), oil on canvas, 1984
Ms. Changa Ben-Dov, Los Angeles,
California

SCHOOL OF WINSLOW HOMER
39 x 42 (99 x 107), oil on canvas, 1986
George Perutz, Dallas, Texas

BARBIZON SCHOOL
36 x 42 (91 x 107), oil on canvas, 1986
Stephen D. Paine, Boston, Mass.

HOOSIER SCHOOL
24 x 32 (61 x 81), oil on canvas, 1987
Mrs. Guthrie May, Evansville, Indiana

SCHOOL OF DEGAS
34 x 42 (86 x 107), oil on canvas, 1986
Charles Hirschorn, Santa Monica,
California

SCHOOL OF SARGENT
60 x 50 (152 x 127), oil on canvas, 1986
Jay Spectre, Inc., New York

ASHCAN SCHOOL
40 x 48 (102 x 122), oil on canvas, 1987
Nancy Hoffman Gallery, New York

THE FAUVE SCHOOL
26 x 30.5 (66 x 77.5), oil on canvas,
1989
Nancy Hoffman Gallery, New York

L'ECOLE DE PARIS
44 x 60 (112 x 152), oil on canvas, 1989
Mr. and Mrs. James Spiegel, Stuart,
Florida

SCHOOL OF JUAN GRIS
15 x 13 (38 x 33) including frame, oil

on canvas, 1989
Nancy Hoffman Gallery, New York

SCHOOL OF MATISSE 1
46 x 54 (117 x 137), oil on canvas, 1987
Jay Spectre, Inc., New York

SCHOOL OF MODIGLIANI
14 x 20 (36 x 51), oil on canvas, 1988
Neale M. Albert, New York

SCHOOL OF MATISSE 2
46 x 54 (117 x 137), oil on canvas, 1988
Jay Spectre, Inc., New York

SCHOOL OF DE CHIRICO
30 x 34 (76 x 86), oil on canvas, 1989
Nancy Hoffman Gallery, New York

SCHOOL OF HOPPER
40 x 50 (102 x 127), oil on canvas, 1985
Mrs. Rosaline Krasney, Pepper Pike,
Ohio

SCHOOL OF BALTHUS
34 x 42 (86 x 107), oil on canvas, 1985
Mr. and Mrs. Thurston Twigg-Smith,
Honolulu, Hawaii

SCHOOL OF STUART DAVIS
24 x 28 (61 x 71), acrylic on canvas,
1987
Nancy Hoffman Gallery, New York

BAUHAUS SCHOOL
50 x 50 (127 x 127), oil on canvas, 1987
Jay Spectre, Inc., New York

THE NEW YORK SCHOOL
52 x 44 (132 x 112), oil on canvas, 1989
Andrew Gates, Bristol, Rhode Island

SCHOOL OF THOUGHT
35 x 39 (89 x 99), oil on canvas, 1985
Jay Spectre, Inc., New York

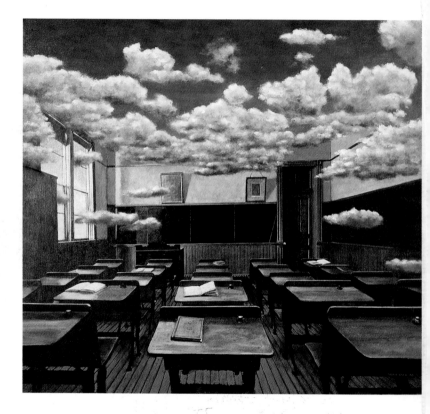

SCHOOL OF THOUGHT